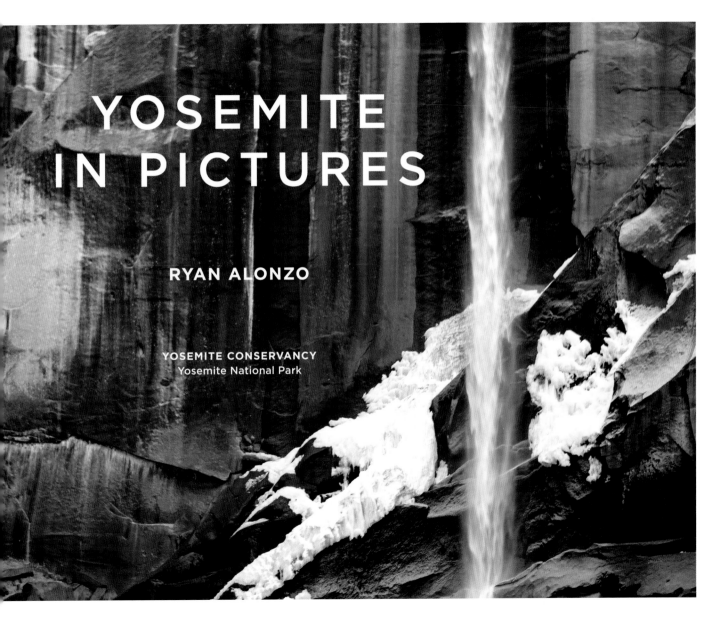

YOSEMITE IN PICTURES

RYAN ALONZO

YOSEMITE CONSERVANCY
Yosemite National Park

YOSEMITE
CONSERVANCY.

yosemiteconservancy.org

Front cover photograph: Autumn blushes
yellow in the Valley. Glaciers once poured
down from Tenaya Canyon, in the distance.

Back cover photograph: Gates of the Valley.

Cover photography by Ryan Alonzo

Design by Nancy Austin

ISBN 978-1-930238-47-3

This book was printed on paper from
sustainable sources.

Printed in China by Everbest Printing Co.
through Four Colour Imports Ltd., Louisville,
Kentucky

2 3 4 5 6 – 18 17 16

FSC
www.fsc.org

MIX
Paper from
responsible sources
FSC® C124385

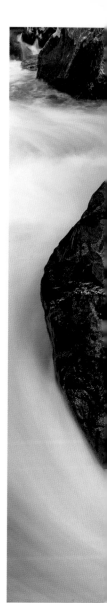

Previous page: The poetry of water
and granite in Yosemite.

A wonderland of glacially
carved granite, Yosemite was
the first piece of land in the
world preserved by a nation
for its natural beauty. To this
day, this drama of water and
rock provides rich alpine
habitat and inspires millions
of visitors every year.

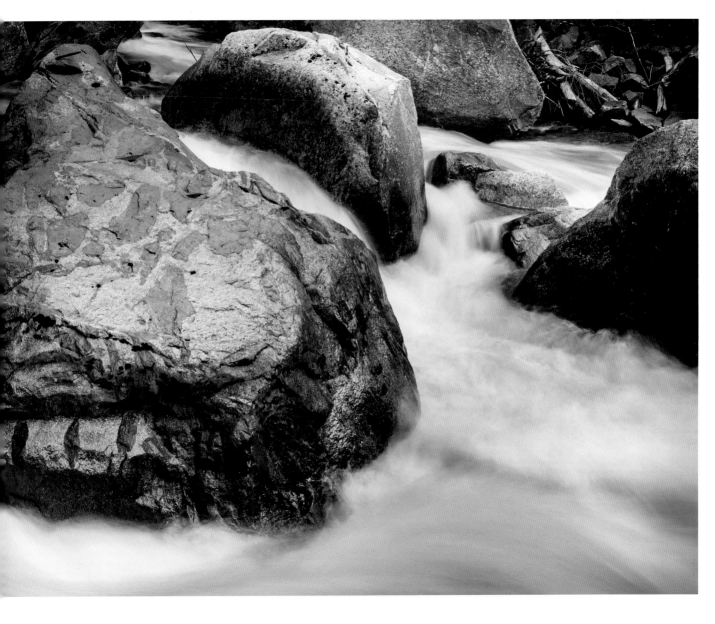

YOSEMITE VALLEY

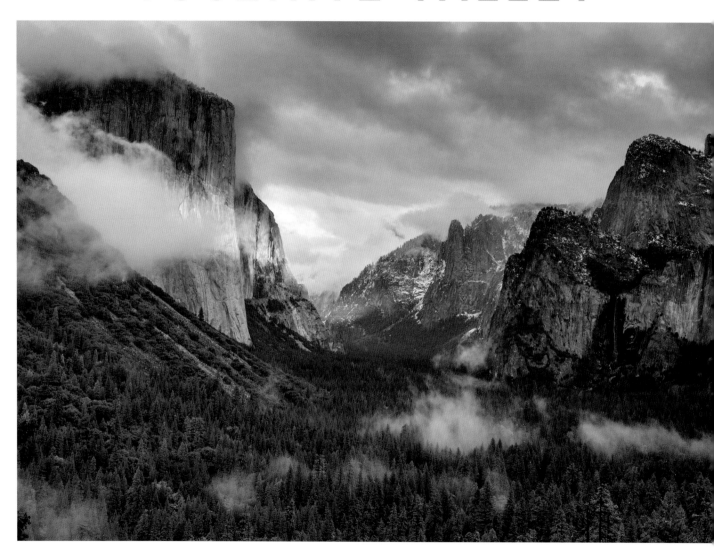

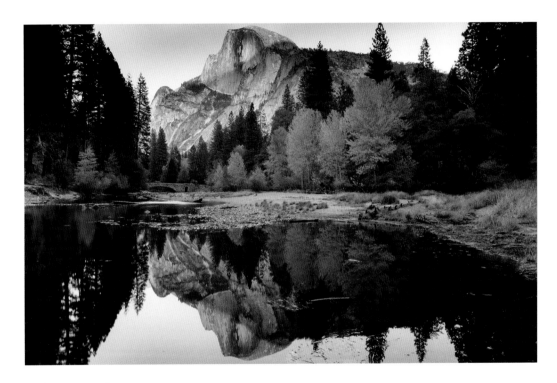

Half Dome, cut by sunset.

Granite rock formations eroded by glaciation define Yosemite grandeur. From Tunnel View on the Wawona Road, El Capitan, Bridalveil Fall, and Half Dome (hidden in cloud) align in a single breathtaking view

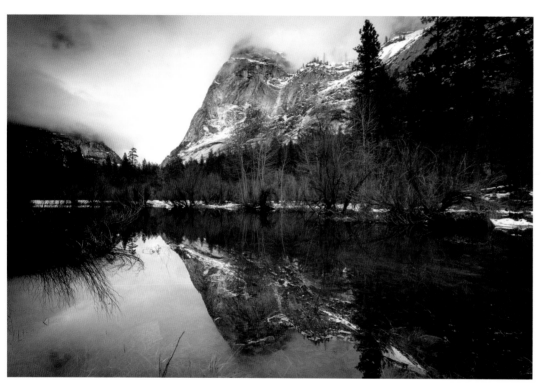

Perfect stillness of Mirror Lake reflects
winter trees, clouds, and snow.

A clear autumn afternoon below El Capitan.
This rock was called Tu-toc-a-nula,
"the Rock Chief," by the Ahwahneechee.

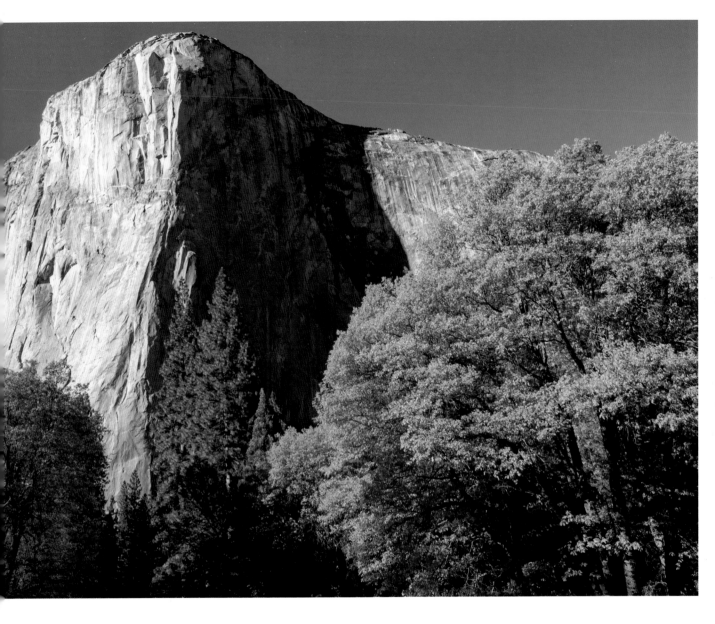

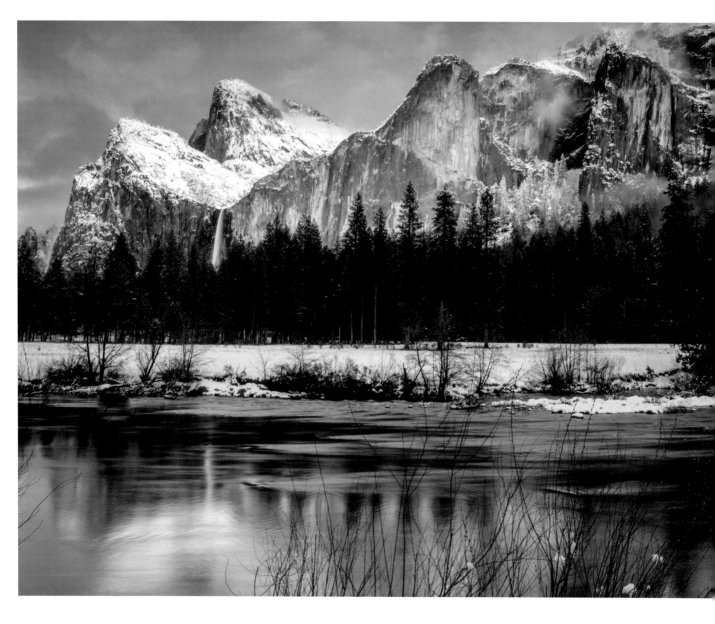

The unbroken face of El Capitan, 3,000 feet (914 meters) tall,
reflects into a foot-deep puddle.

Afternoon sun lifts the winter mist on
Bridalveil Fall, called Pohono by the
Ahwahneechee for the winds that blow
the stream as it falls.

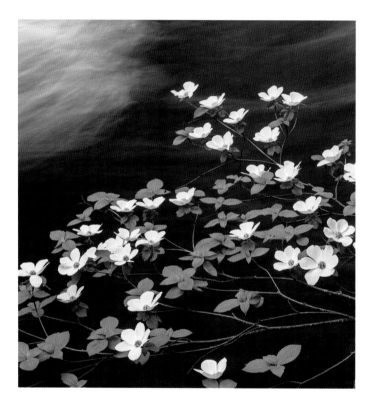

Harmonizing with rising meltwater, dogwood blossoms
(*Cornus nuttallii*) are a delight of spring in Yosemite Valley.

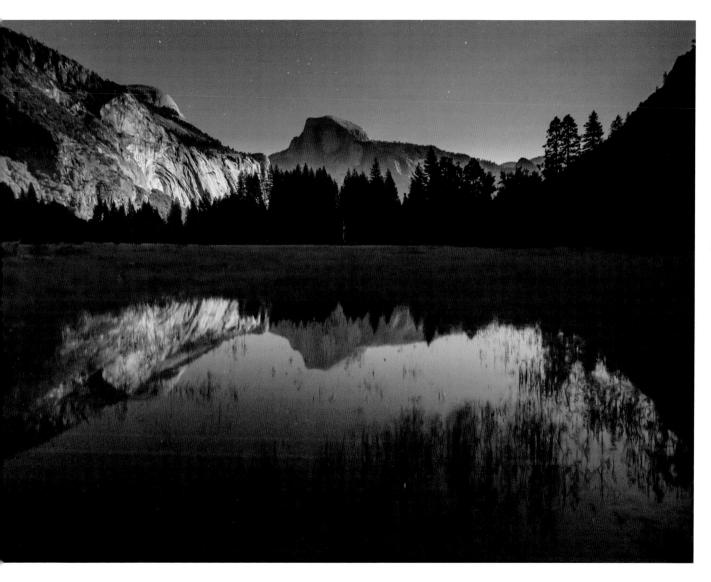

The silent power of Half Dome doubles in a wet meadow.

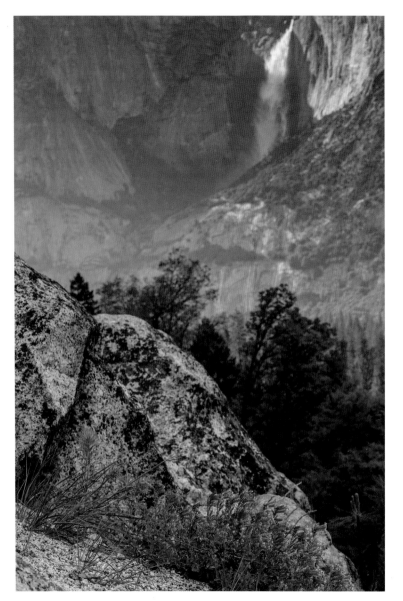

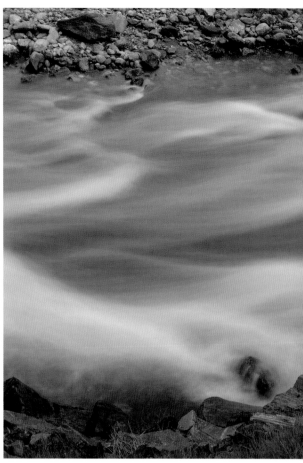

Yosemite Falls as backdrop to a proud drama in the crack of a rock: great red Indian paintbrush (*Castilleja miniata*) and mountain pride (*Penstemon newberryi*) in summer bloom.

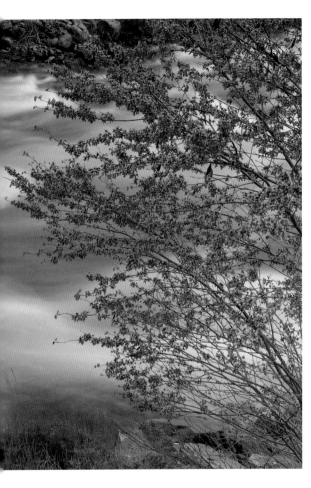

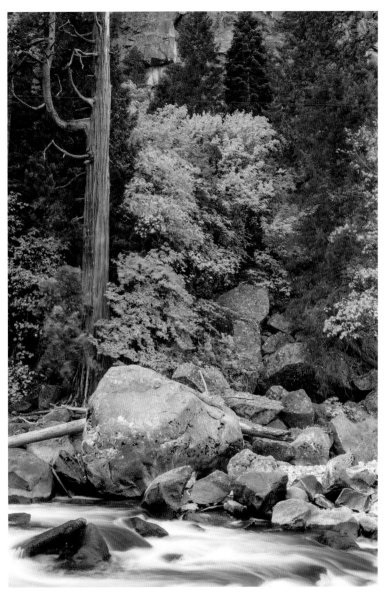

Above: Western redbud (*Cercis occidentalis*) blooms in spring on the Merced River.

When the river drops, awaiting winter storms, aspen trees display brilliant autumn color.

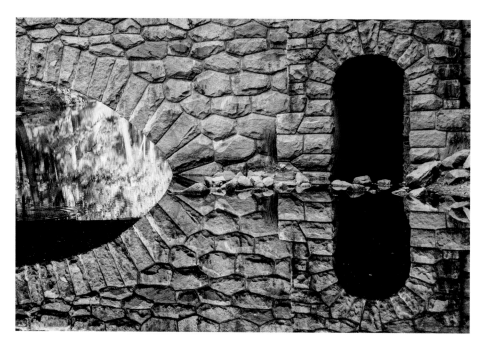

Stoneman Bridge, built in 1933, replaced a wooden bridge
called "Royal Arch Avenue."

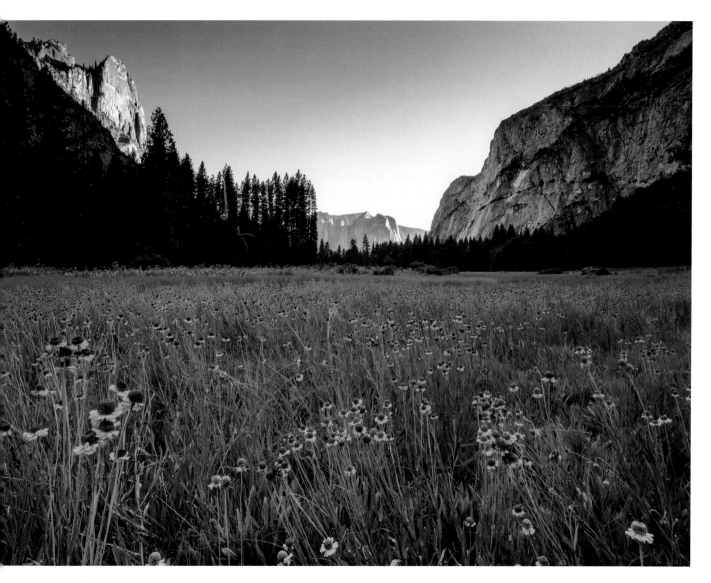

Sneezeweed (*Helenium bigelovii*, a member of the sunflower family) carpets the wet Valley floor.

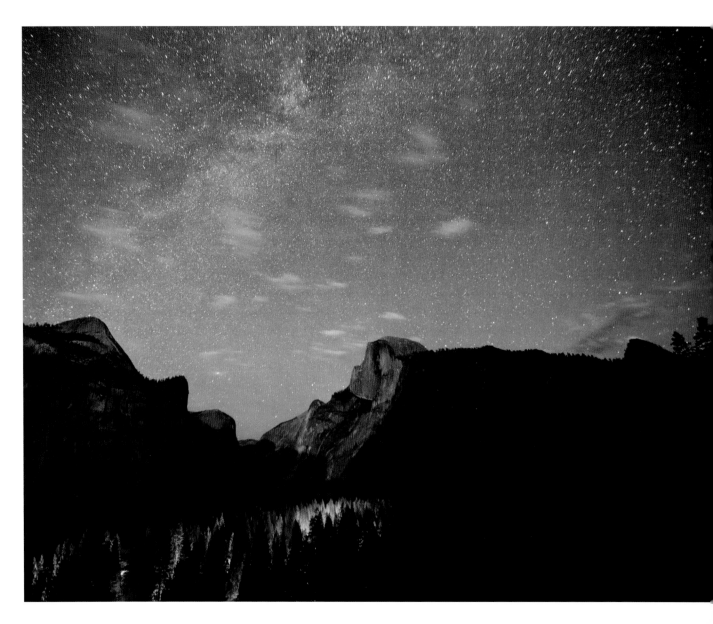

American Indian people have called Yosemite home for thousands of years. The most recent cultural group called the valley Ahwahnee and themselves Ahwahneechee. The granite ripples of Yosemite Valley echo the musculature of the arms of the Milky Way. Dark night skies in national parks like Yosemite keep us in touch with the ancient lore of stars and the grandeur of our home galaxy.

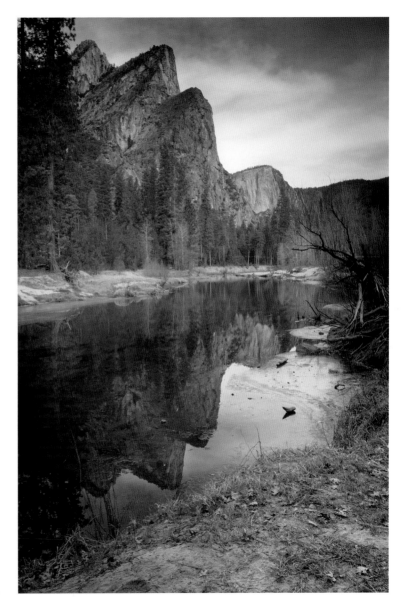

Three Brothers in early winter.

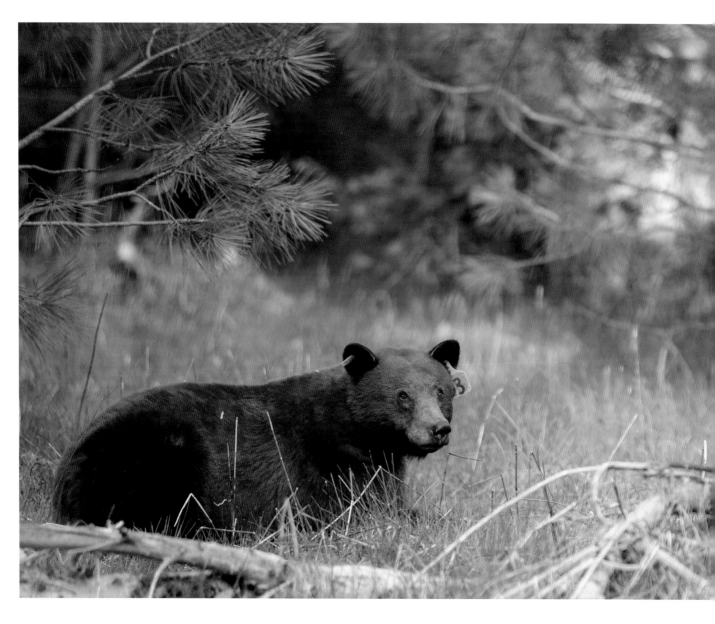

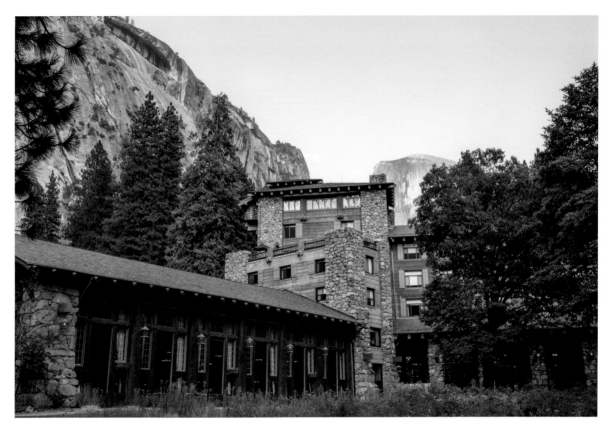

This American black bear (*Ursus americanus*) enjoys the edge of a meadow. The Yosemite bear management team, park staff, and visitors work together to keep bears like him from obtaining calorie-rich human food, in hopes they return to natural habits. These extremely intelligent omnivores can be difficult to discourage from human-dominated areas once they develop a taste for human food.

The Ahwahnee retains the American Indian name of Yosemite Valley, which translated to "valley like a big open mouth." The angles of the building are meant to mimic the walls of Royal Arches and Half Dome looming behind.

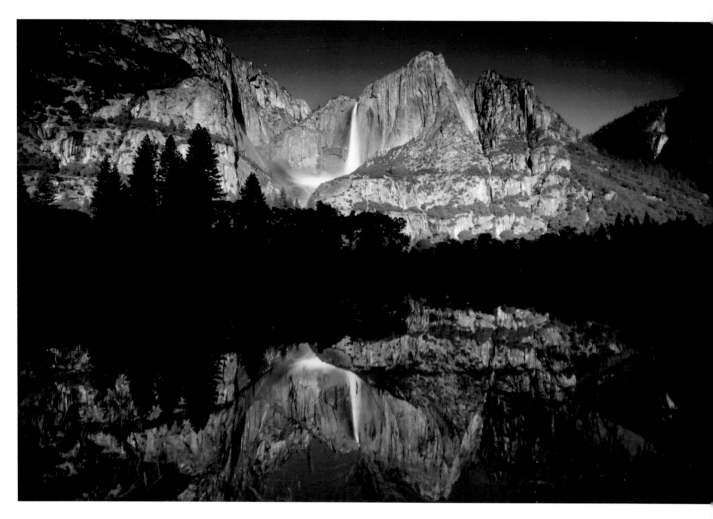

A play of color in the dark: the moonbow at Yosemite Falls.

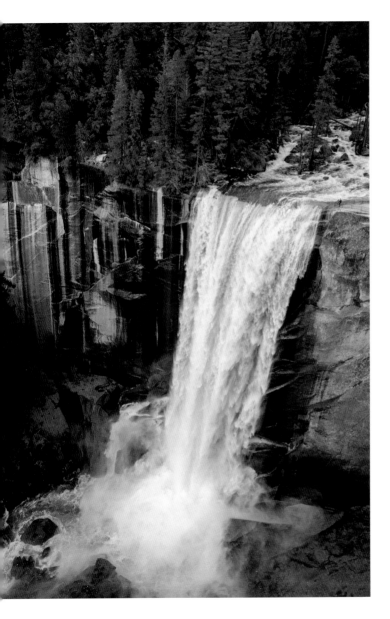

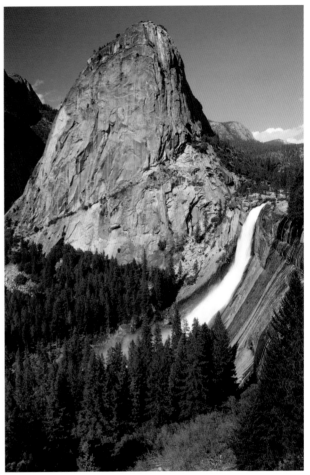

The Wild and Scenic Merced River spills over Nevada Fall (above) and Vernal Fall (left).

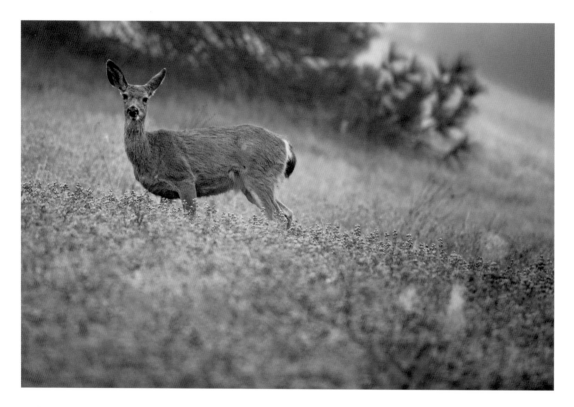

Mule deer *(Odocoileus hemionus)* in a meadow of lupine *(Lupinus sp.)*.

Dark lichens mark paths of water on the face
of Royal Arches and Washington Column.

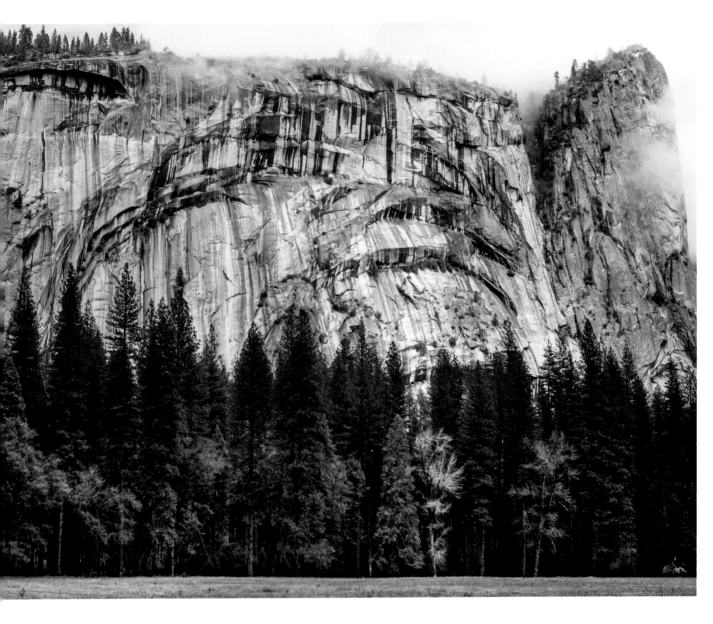

Superintendent's Bridge, humble before the timeless beauty of Yosemite Falls. In three plumes, this awe-inspiring waterfall drops a total of 2,425 total feet (739 meters) to the Valley floor.

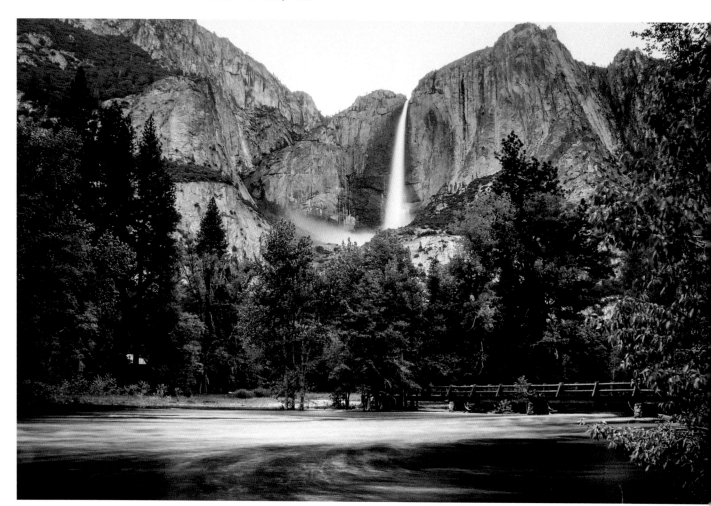

Upper Yosemite Fall is patterned by the wind as it plummets 1,430 feet (436 meters) through thin air. Ahwahneechee legends warned of strong winds around the pools, controlled by witches who lived there.

MARIPOSA GROVE

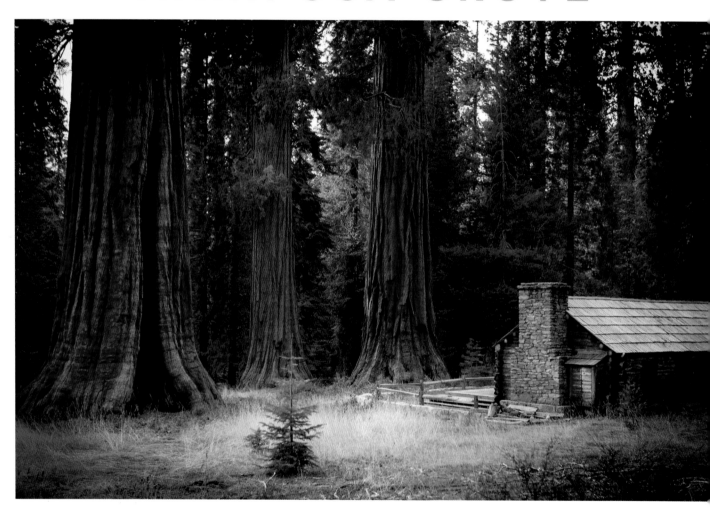

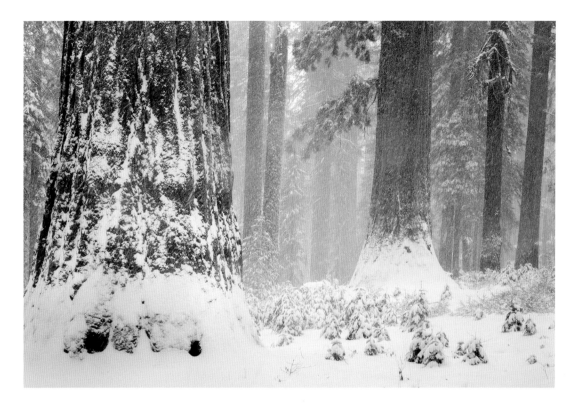

Sequoias in the snow.

Due in part to Galen Clark's efforts, Congress passed the Yosemite Grant in 1864. He became the "Guardian of the Grant" and spent decades living among the giant sequoias (*Sequoiadendron giganteum*), protecting them and teaching people about them. The current museum currently stands on the site where he built a cabin in 1864.

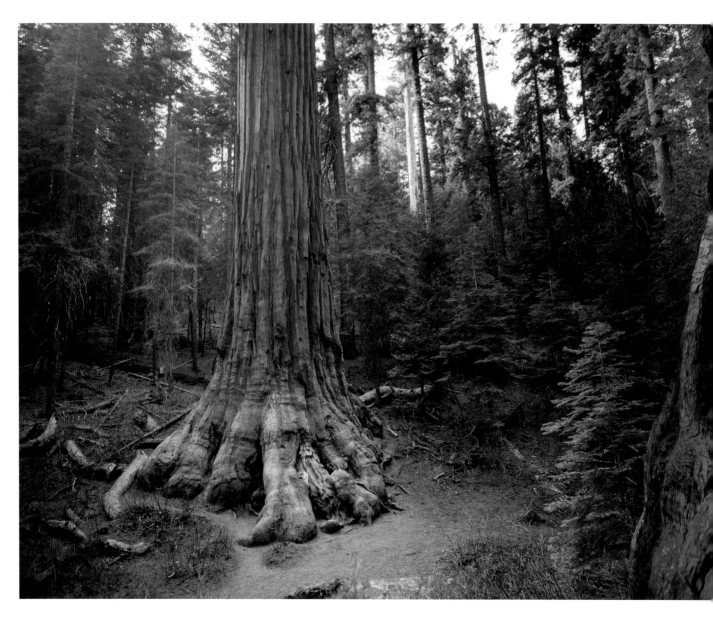

Left: Giant sequoias provide habitat for Douglas squirrels, flying squirrels, bats, owls, and also white-headed woodpeckers, who feed on carpenter ants that live in the trees.

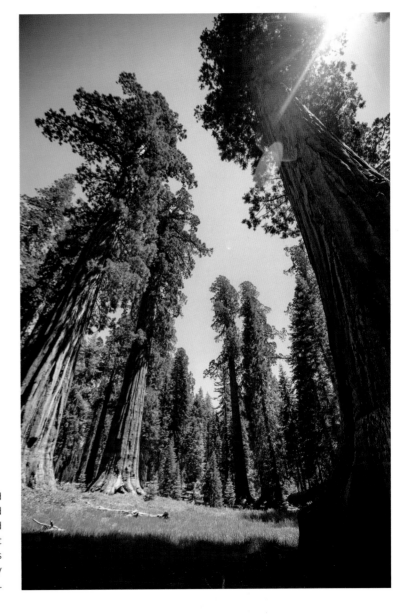

Right: Resilient, ancient, and massive, giant sequoias have awed generations. These trees helped inspire the Yosemite Grant, the first law to protect a piece of land for its natural beauty, signed into law by Abraham Lincoln in 1864.

GLACIER POINT

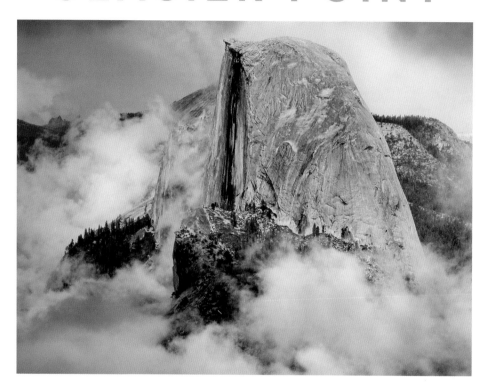

Millions of misty mornings have crowned this lichen-stained icon; millions of minds in the mist have been amazed, overwhelmed, and inspired by this view of Half Dome from Glacier Point. Glaciers rippled and smoothed this granite as they poured down Tenaya Canyon.

From huge rock walls carved by the eons, to rich forest and meadow habitats, to ephemeral blossoms alive with bees on a summer afternoon; Yosemite sustains many layers of beauty.

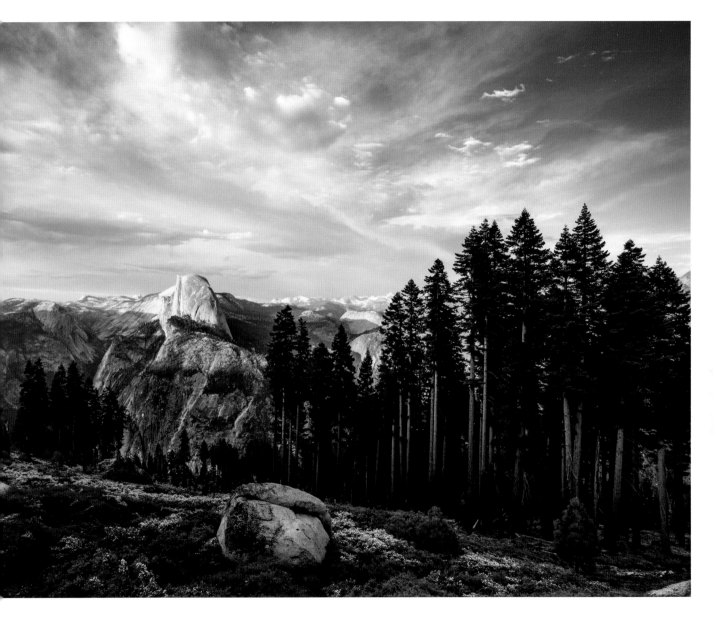

Last light graces the face of El Capitan from Taft Point. The face was first climbed in 1958 by Wayne Merry, George Whitmore, and Warren J. Harding.

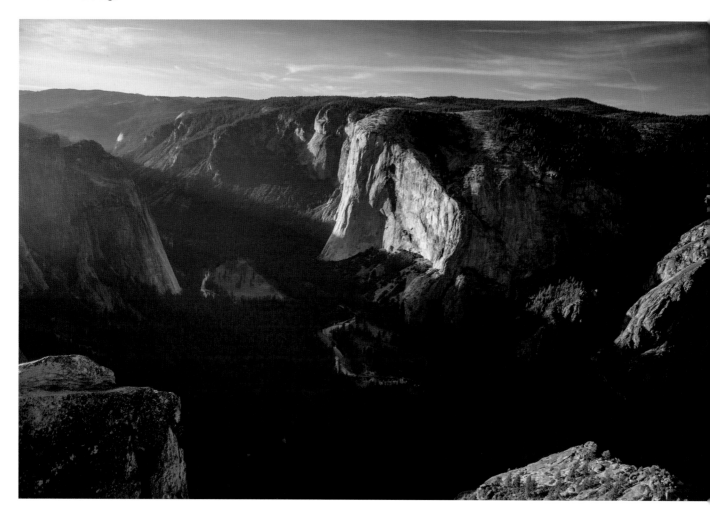

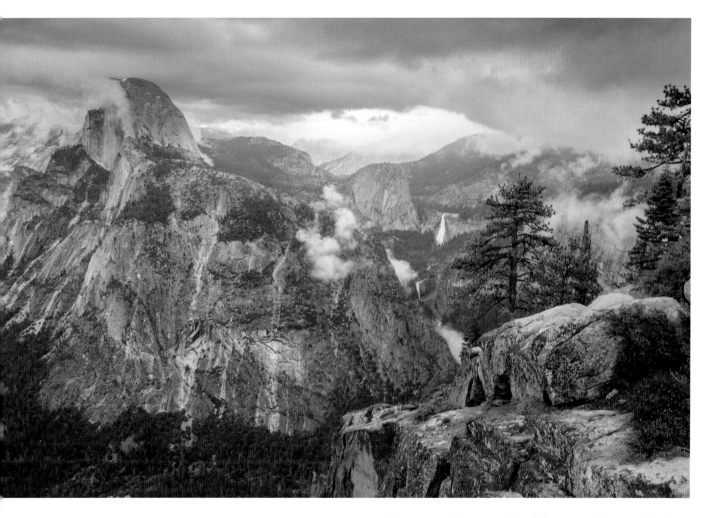

These magnificent granite cliffs teem with green life, from montane forests of cedar, sequoia, and oak; to subalpine forests of lodgepole pine, mountain hemlock, and mountain juniper; to high meadows of grasses, sedges, and willow; to vertical rock faces that bristle with moss and lichen.

TUOLUMNE MEADOWS

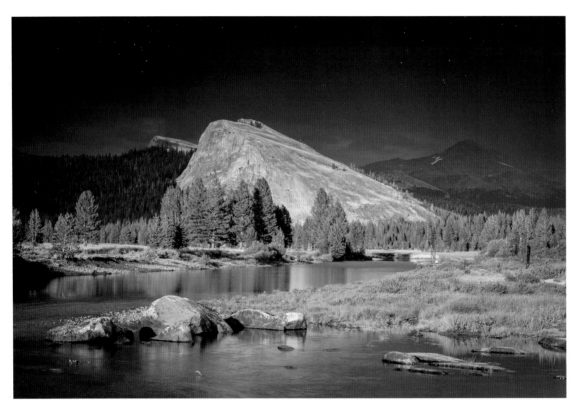

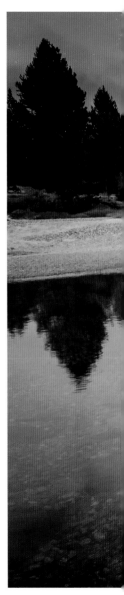

Storms hang on the east crest of
the Sierra behind Lembert Dome in
Tuolumne Meadows.

The Wild and Scenic Tuolumne River flows off
the snowbanks of the Sierra Crest, meanders
lazily through Tuolumne Meadows, and pours
down the Grand Canyon of the Tuolumne.

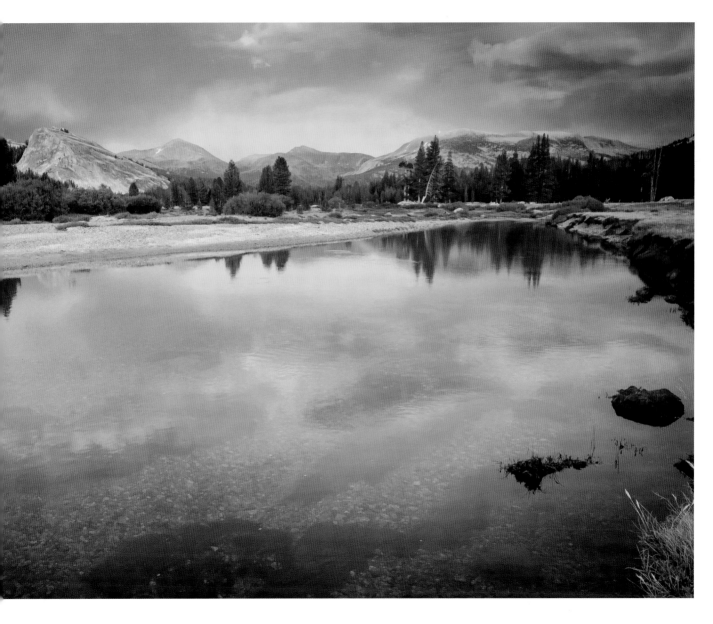

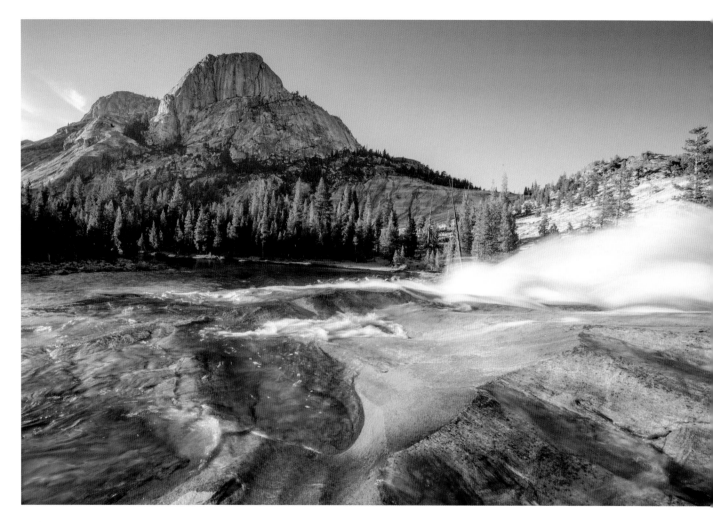

In the Grand Canyon of the Tuolumne, prehistoric forces of glaciation and river-polish meet the perfect moment of evening sunlight: an epiphany of water and granite.

Water, in various forms over eons, sculpted all the treasured granite formations of Yosemite. From spectacular waterfalls to still crystalline pools, clean Sierra snowmelt cascades dramatically through the mountains till it reaches valleys below.

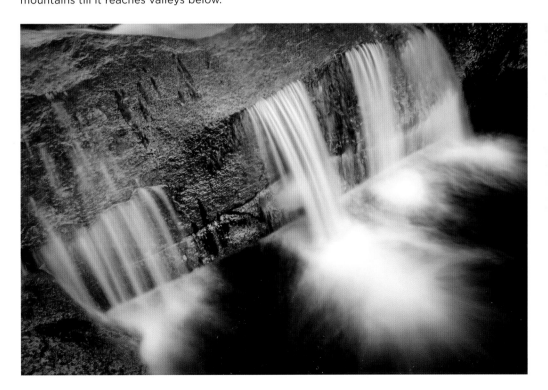

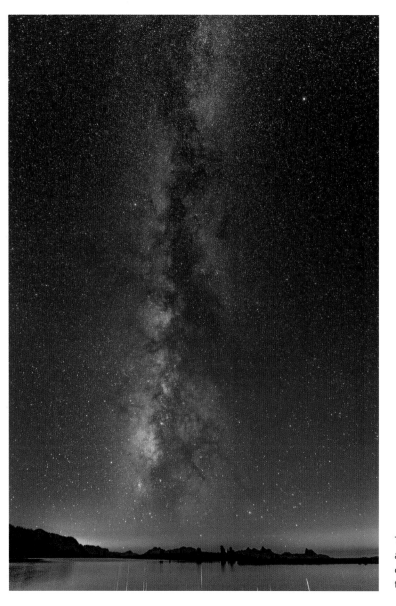

The Cathedral Range frames
an enormous sky. Dark clouds
of intergalactic dust marble the
texture of the Milky Way.

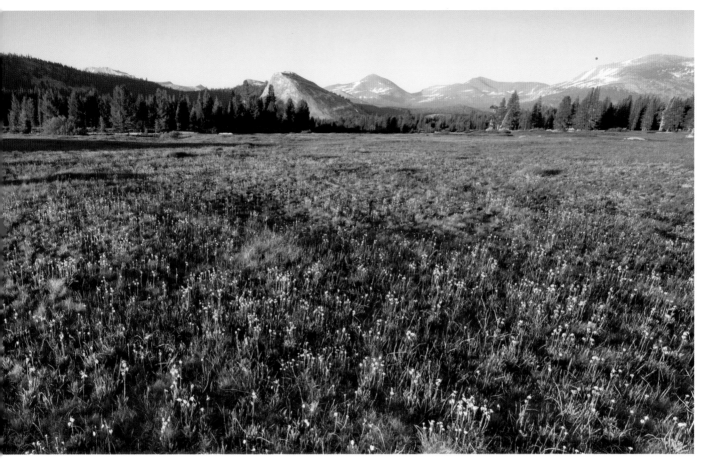
Subalpine shooting stars (*Dodecatheon subalpinum*) blush in Tuolumne Meadows in the boon of summer.

HIGH COUNTRY

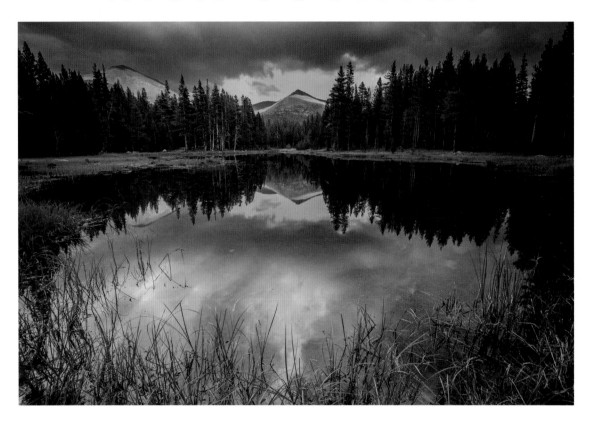

Metamorphic Mount Dana (above left) and Mount Gibbs (above right) loom on the east edge of Yosemite National Park.

These Coville's lupine (*Lupinus covillei*) below Cathedral Peak will go through a rapid cycle of blooming, seeding, and gathering energy for next spring in the fleeting growing season before snow reclaims the high-country landscape

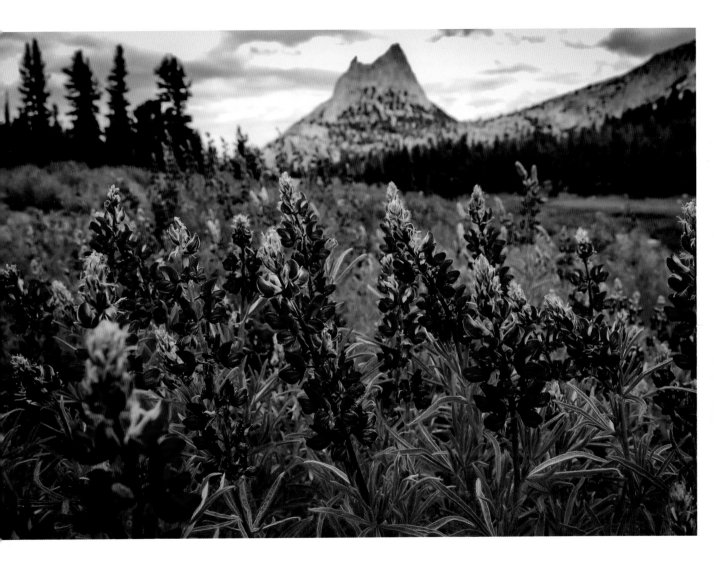

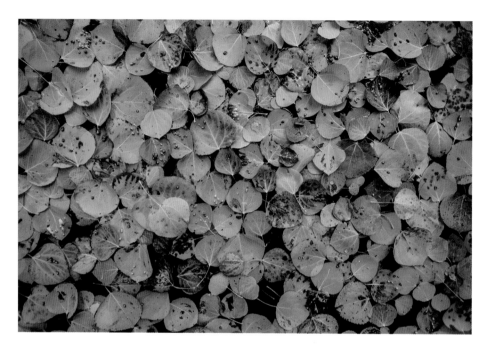

Quaking aspen leaves (*Populus tremuloides*): autumn gold afloat.

High-country sunset. Trees are sparse in this landscape dominated by winter snow. In summer, this high meadow hosts a celebration of tiny alpine flowers, butterflies, frogs and toads, and many bird species.

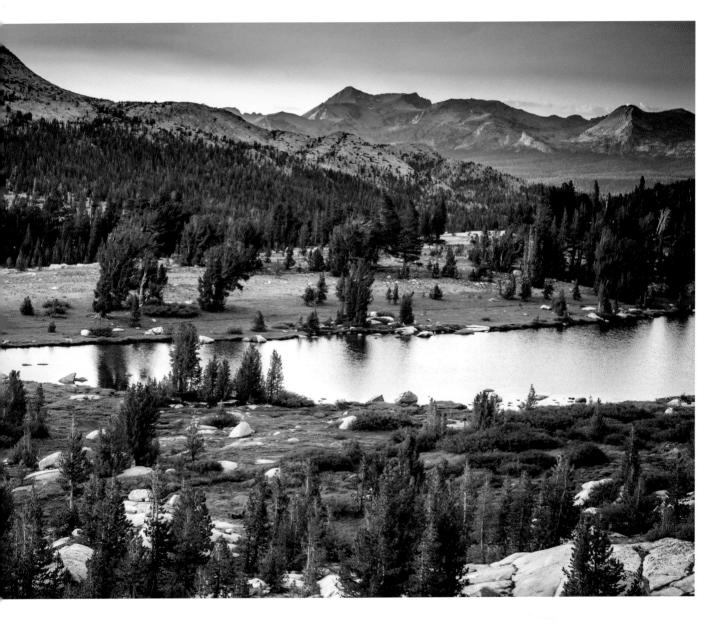

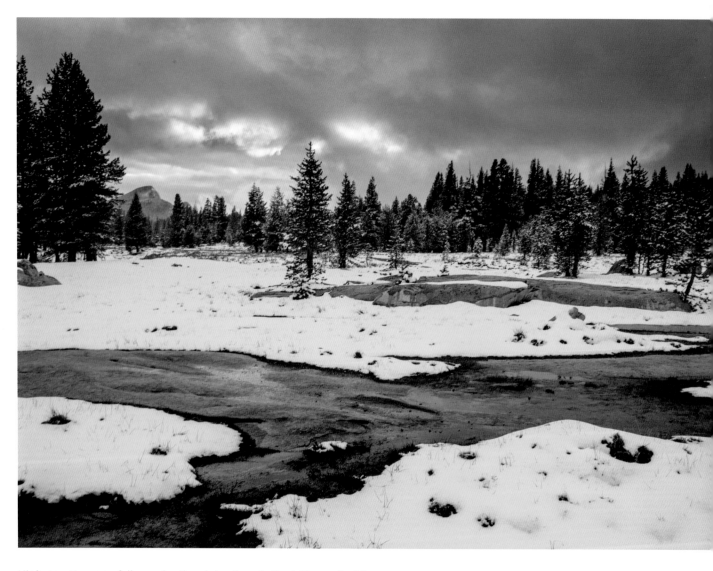

High-country snowfalls render the alpine forest silent. The rest of the
year, the snow flows as water throughout the state of California.

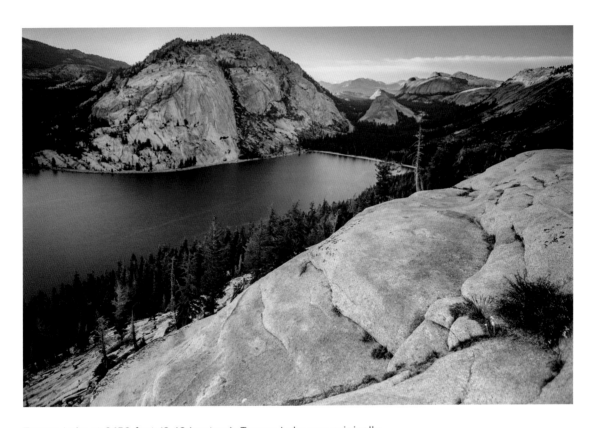

Tenaya Lake at 8,150 feet (2,484meters). Tenaya Lake was originally called Py-we-ack ("lake of the shining rocks") by the Ahwahneechee, perhaps for the glacial polish on surrounding domes.

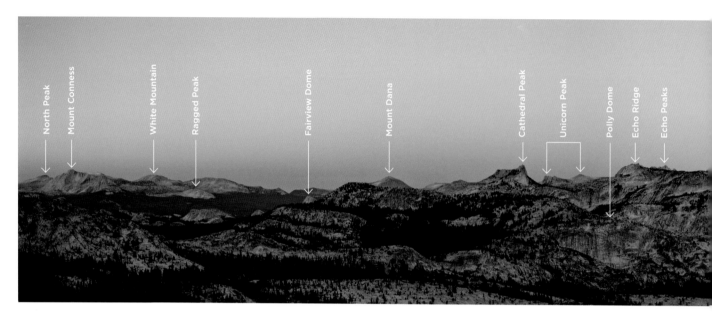

North Peak · Mount Conness · White Mountain · Ragged Peak · Fairview Dome · Mount Dana · Cathedral Peak · Unicorn Peak · Polly Dome · Echo Ridge · Echo Peaks

Looking east at the Cathedral Range and beyond.

"[There] rose the mighty Sierra, miles in height, and so gloriously colored and so radiant, it seemed not clothed with light, but wholly composed of it. . . . Then it seemed to me that the Sierra should be called, not the Nevada or Snowy Range, but the Range of Light."
—John Muir, *The Yosemite*, 1912

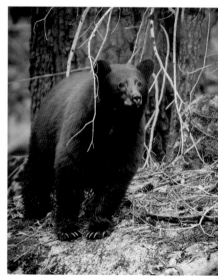

With a sense of smell that informs him of miles of forest at a sniff, the American black bear is master of the seasonal lifestyle of the Sierra Nevada.

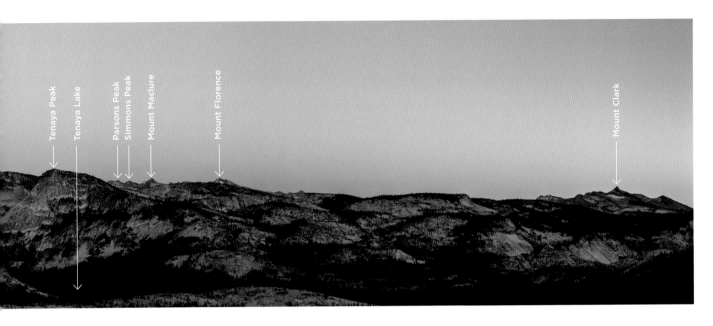

Tenaya Peak • Tenaya Lake • Parsons Peak • Simmons Peak • Mount Maclure • Mount Florence • Mount Clark

Where the mountains meet the sky, geology and atmosphere interact to create the rich mountain landscape that is Yosemite National Park.

YOSEMITE
CONSERVANCY.

Providing For Yosemite's Future

Through the support of donors, Yosemite Conservancy provides grants and support to Yosemite National Park to help preserve and protect Yosemite today and for future generations. Work funded by the Conservancy is visible throughout the park, in trail rehabilitation, wildlife protection and habitat restoration. The Conservancy is also dedicated to enhancing the visitor experience and providing a deeper connection to the park through outdoor programs, volunteering, wilderness services and its bookstores. Thanks to dedicated supporters, the Conservancy has provided more than $100 million in grants to Yosemite National Park.

yosemiteconservancy.org